Wet-into-Wet

WATERCOLOUR TECHNIQUE

Bryan A.Thatcher

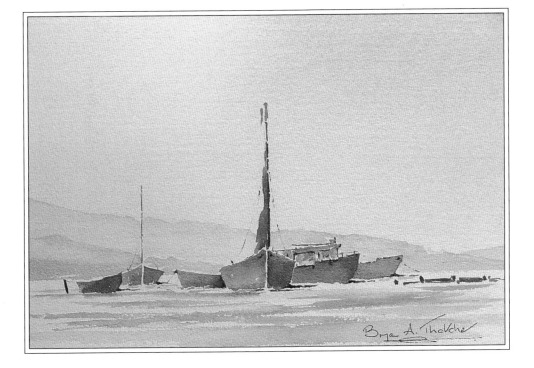

SEARCH PRESS

First published in Great Britain 1995

Search Press Limited
Wellwood, North Farm Road,
Tunbridge Wells, Kent, TN2 3DR

Reprinted 1996

ISBN 0 85532 787 1

Publishers' note
There is reference to sable hair and other animal hair brushes
in this book. It is the publishers' custom to recommend
synthetic materials as substitutes for animal products wher-
ever possible. There are now a large number of brushes
available made from artificial fibres and they are just as
satisfactory as those made from natural fibres.

Page 1
Boats near Whitesands Bay, South Wales.
Original size 380 x 560mm (15 x 22in).

Printed in Spain by Elkar S. Coop, Bilbao 48012

Contents

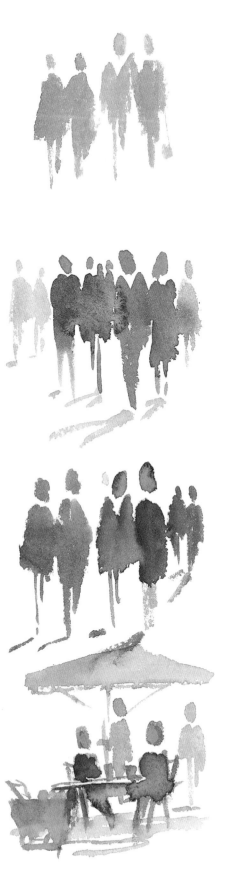

Introduction

The essence of watercolour is its transparency and fluidity, and the technique of painting wet-into-wet, which means painting on a surface which is already wet, really brings out these qualities. You can achieve some wonderful flowing effects for skies, landscapes, water, trees and a host of other subjects, simply by controlling and experimenting with your washes of colour. I always love to see wet colours fusing and blending on the paper; however many times I do it, I still find it exciting.

To make it all look so effortless, you will have to put in a bit of practice, of course, but this sort of experimenting is always fun. I have included some exercises on mixing colours and ways of painting different subjects, then I show you in detail, step-by-step, how to paint pictures wet-into-wet.

About wet-into-wet painting

The most important thing is to understand the effects of the degree of wetness of the paint on both the brush and the paper.

The four illustrations (below) indicate the results of various degrees of wetness. You will see that the wet-into-wet example has fused the colours together in a most attractive manner. The damp-into-damp and the damp-into-wet examples have also worked quite well. In the last example, though, the wet brush placing wet colour into a previously applied damp colour has resulted in an unattractive drying stain. (See also the example on page 19).

It is well worth remembering that wet-into-damp usually results in disasters, so do plan your painting so that the second colour is ready to use before the first has dried out. When your work becomes more advanced there may be occasions when this technique can be used to create some special effects, but for now be wary of using it.

The wet-into-wet technique is rewarding when laying down an initial wash: it can give a painting lots of 'atmosphere'. Use blues and greys for cool distant backgrounds, or add a little red to give a touch of warmth to your background. I have given some examples of different coloured skies on pages 14 and 15.

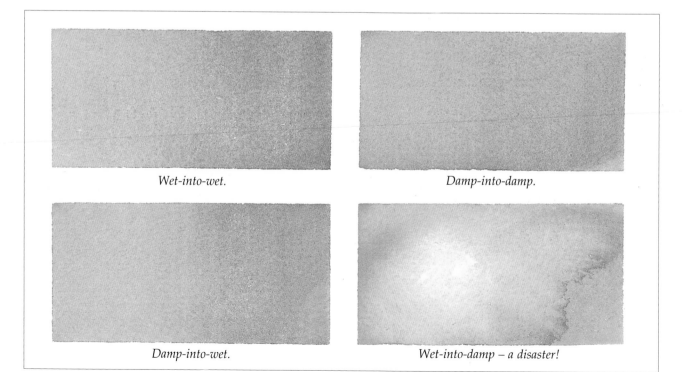

Wet-into-wet.

Damp-into-damp.

Damp-into-wet.

Wet-into-damp – a disaster!

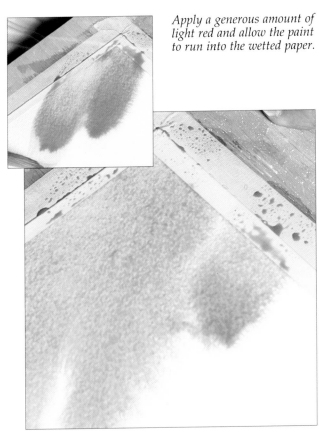

Apply a generous amount of light red and allow the paint to run into the wetted paper.

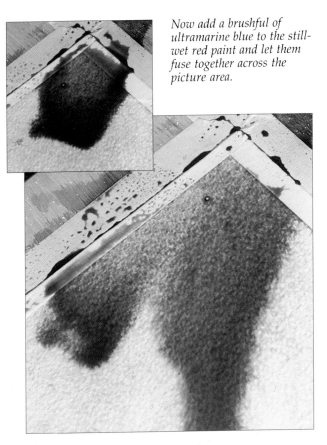

Now add a brushful of ultramarine blue to the still-wet red paint and let them fuse together across the picture area.

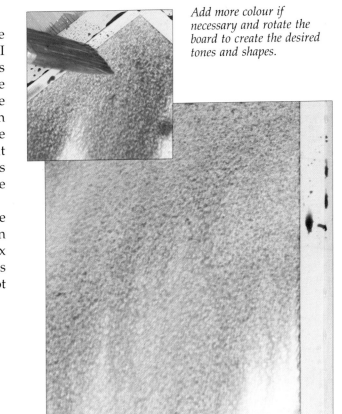

Add more colour if necessary and rotate the board to create the desired tones and shapes.

Laying a two-colour wash

The illustrations on this page show how exciting the fusing of one colour into another can be. First I wetted the whole area to be painted with a generous amount of clean water. Then I applied light red to the top corner of the paper and allowed it to run into the wetted area. I followed this with another brush loaded with ultramarine blue and let this run into the wet red. You must paint fairly quickly to ensure that the first wash is still wet when the second colour is added, so ensure that both colours are mixed in the palette before starting the first wash.

People often fail to mix enough colour in the palette. It is far better to mix more than you need than to run out of colour. If you do run out and have to mix more you may find that the paint on the paper has already dried out too much. A second colour will not fuse properly with a dried-out first colour.

Materials and equipment

There is little doubt that the better and more suitable the materials, the better are the chances of success. However, this need not mean that you will have to buy the most expensive brushes, papers and paints. Here is a list of the materials and equipment that I use. Not all of them are essential for a successful painting, but I find them all very worth while.

1. Brushes

I use a 38mm (1½in) flat bristle brush for all my washes. I have three of them so that I can pre-mix my washes with different brushes. I do not have to clean a brush between each colour and this allows me to get a second colour on before the first dries out.

The beautiful chisel edges of 25 and 50mm (1 and 2in) flat hair brushes are very useful for painting suggestions of masts on boats, telegraph poles and all kinds of upright and horizontal brush marks.

I also use No. 4, 6, 8 and 10 round brushes – part sable/part synthetic hair brushes which are much cheaper than pure sable ones. They hold colour pigments very well and I use them a lot.

A No. 3 or 4 pointed rigger brush is essential for any fine line work such as the branches on trees, wire fences and the rigging on boats.

2. Palette and water jar

Apart from my paint box (see page 8) I also use this 'palette' for mixing my washes. It is a plastic utensil tray with a number of compartments in which I can mix relatively large quantities of colour wash. I also use a couple of small jars for cleaning my brushes.

3. Mounts and boards

I like to have a picture mount of a suitable size to hand while I am on a painting exercise so that I can preview the finished work.

A painting board cut from a piece of 6mm (¼in) thick plywood slightly larger than your paper will prove invaluable as a support while painting.

I always have a transparency mount with me when painting; I find it useful for picture composition.

4. Watercolour paper

It is worth buying the best possible watercolour paper. For painting wet-into-wet you will need a

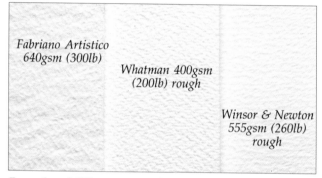

Examples of different watercolour papers.

reasonably heavyweight paper that will not cockle when wet. Of the three types of surface finish (hot pressed (smooth), not (semi-rough) and rough) I prefer to use rough-surfaced papers. I normally use at least a 400gsm (200lb) paper and if I am painting a large picture I will choose a 640gsm (300lb) paper. If you use a lighter weight of paper I recommend that you stretch it as described on pages 12–13. It is more economical to buy large sheets which can be cut down to the size you need.

5. Craft knife

This is not essential but a craft knife can be useful.

6. Pens, pencils and erasers

I like to have a fine black drawing pen to add very fine detail to my pictures. I also have a selection of pencils and a putty eraser for cleaning off pencil marks.

7. Hair dryer

I use a small hair dryer for drying damp washes only. It must not be used to dry wet-into-wet washes as it will blow paint on to areas where it is not required. Wet washes must be laid on a flat surface to dry out slightly before using the hair dryer.

8. Stencils, sponge and tissue paper

I use paper stencils and a sponge for removing dry paint from the paper, to create a moon for example. The tissues are ideal for cleaning excess moisture and paint from the edges of the painting and also for lifting out suggestions of clouds from wet skies.

9. Tape

Masking tape is best for fixing your paper to your board. You will also need some gummed brown-paper tape for stretching those lighter-weight papers.

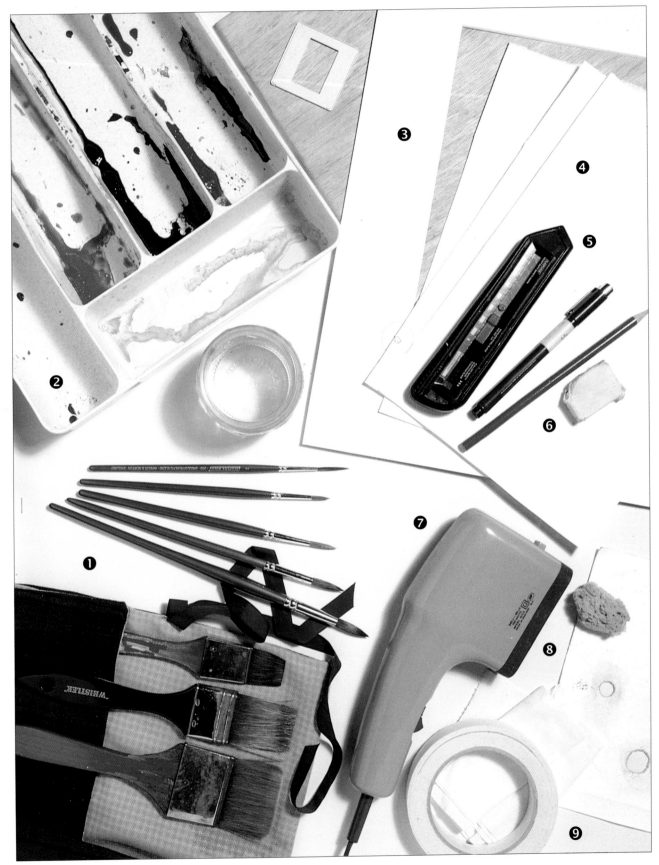

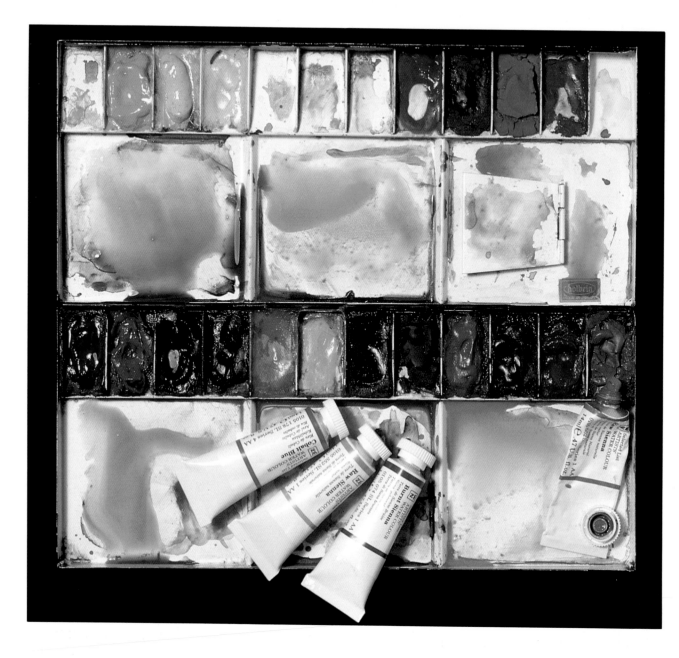

Colours

My regular palette consists of fifteen colours to which I add two or three other colours that I might want for a specific subject. The individual colours all have particular uses and can be mixed to provide a very wide range.

Light red. I use this colour extensively in my washes when a warm atmosphere is required. It can be a little opaque so it must be used in moderation. I rather like its tendency to granulate, especially if mixed with ultramarine blue. It is also a good colour for brickwork and buildings.

Burnt sienna. A good autumn colour – and I cannot imagine painting a landscape without it. It offers a good range of greys when mixed with the blues in my palette and it is also useful for toning down green foliage and to indicate buildings.

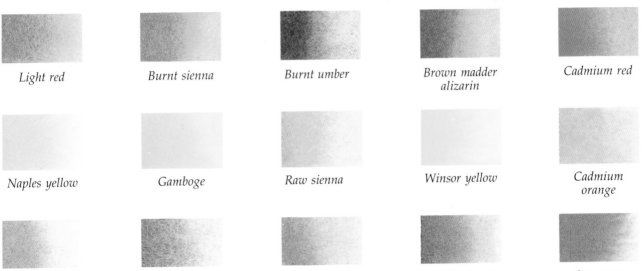

Light red	*Burnt sienna*	*Burnt umber*	*Brown madder alizarin*	*Cadmium red*
Naples yellow	*Gamboge*	*Raw sienna*	*Winsor yellow*	*Cadmium orange*
Cobalt blue	*Ultramarine blue*	*Winsor blue*	*Neutral tint*	*Sap green*

Burnt umber. Burnt umber will provide a whole range of greys when mixed with blues, and it has a particularly strong tendency to granulate with ultramarine blue. It is good for shadows when mixed with neutral tint and also for toning down greens.

Brown madder alizarin. This is one of my favourite colours. I use it regularly with neutral tint to give a warm dark rather than using any black. It gives an interesting warmth to a sky wash and is also very useful on its own – a most acceptable red.

Cadmium red. I use this red very sparingly, limiting it to small bright spots such as flags on boats, poppies in a landscape and some figures.

Naples yellow. Use in moderation as it has a tendency to be opaque. However, I use it regularly to indicate a bright sunlit sky. I usually like to warm it up slightly with just a touch of light red. It can also be mixed with blue without a resulting green hue and is very good when dropped into a blue sky with that touch of light red. I also use it in water when reflections of a sunlit sky are required.

Gamboge. I mix gamboge with my blues to increase my range of greens.

Raw sienna. I use this as the base colour for most of my greens. Ready-made greens are quite severe and can dominate a painting – I prefer to mix my greens using one of my three blues. I particularly like the subtle green tones of this colour mixed with some Winsor blue: good for foregrounds and grass.

Winsor yellow. I limit this somewhat bright yellow to indicating colour on figures and other objects. I find it too dominant to mix with blues to make greens, but it is fine if used in very small amounts.

Cadmium orange. This colour is also bright, but it creates interest if dropped into foliage. Good for bright detail on figures and objects; it is also very useful for still-life subjects.

Cobalt blue. This, the coolest of my three blues, gives a wide range of cool greys when mixed with burnt umber, burnt sienna, light red or a little neutral tint. When mixed with just a touch of light red it makes a most acceptable sky-blue tint.

Ultramarine blue. This can be used in a similar way to cobalt blue but the resulting tints are slightly warmer. This colour granulates very well when 'atmosphere' is required. Try it with burnt umber and light red for really good granulation. It is also useful for subtle greens when mixed with raw sienna.

Winsor blue. Winsor blue is very strong, so always use it in moderation. I only use it with my raw sienna or Winsor yellow to make greens.

Neutral tint. This is an good colour to have in a palette – I am never without it. It is very strong in its neat form, so use it sparingly. As its name suggests, it is a true neutral tint when weakened, unlike Payne's grey, which I find too blue and rather flat.

Sap green. This is the only pre-mixed green I use. I do not often use it but it can be dropped into the browns of tree trunks and foliage. With cobalt blue it makes silver-blue hues for the foliage of some plants.

Mixing colours

Do not attempt to use single neat colours direct from the tube or pan – they are normally much too rich and brilliant and in any event it is far more interesting for both the artist and the viewer to see colours emerging that cannot be bought from the art shop. It is a much better idea to discover your own tints: if you use them regularly your work will be recognised as your own, containing your individual choices of colour.

On these pages I have given you an idea of the vast range of tints that can be obtained by mixing colours from a limited palette.

No matter how long you have been painting there are always new colour mixes to be found. It would take a lifetime to discover them all, perhaps longer. It is always a good idea to add new colours to your palette from time to time.

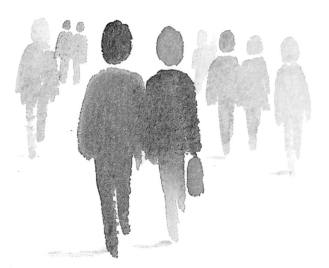

Different colours painted wet-into-wet over an initial wash of light red.

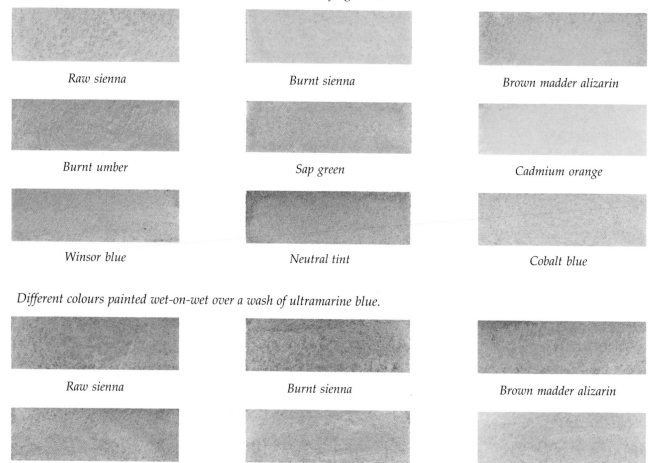

Raw sienna	*Burnt sienna*	*Brown madder alizarin*
Burnt umber	*Sap green*	*Cadmium orange*
Winsor blue	*Neutral tint*	*Cobalt blue*

Different colours painted wet-on-wet over a wash of ultramarine blue.

| *Raw sienna* | *Burnt sienna* | *Brown madder alizarin* |
| *Burnt umber* | *Cadmium orange* | *Naples yellow* |

Greens are perhaps the most difficult colours to control. They can easily dominate a painting. Do not be tempted to use any pure greens – make your own from the range of blues, yellows and oranges in your palette.

*Winsor blue
and raw sienna*

*Winsor blue
and cadmium yellow*

*Winsor blue
and Naples yellow*

*Winsor blue
and cadmium orange*

*Ultramarine blue
and raw sienna*

*Ultramarine blue
and cadmium yellow*

*Ultramarine blue
and Naples yellow*

*Ultramarine blue
and cadmium orange*

*Cobalt blue
and raw sienna*

*Cobalt blue
and cadmium yellow*

*Cobalt blue
and Naples yellow*

*Cobalt blue
and cadmium orange*

There is an endless number of greys available within a limited palette of twelve colours. You may find new ones each time you paint. When you do find new greys, it is helpful to make a note of the colours you used.

*Cobalt blue
and neutral tint*

*Winsor blue
and burnt sienna*

*Cobalt blue
and burnt umber*

*Ultramarine blue
and burnt umber*

*Light red
and cobalt blue*

*Ultramarine blue
and neutral tint*

*Burnt sienna
and Naples yellow*

*Raw sienna
and cobalt blue*

*Burnt sienna
and cobalt blue*

*Winsor blue
and burnt umber*

*Winsor blue
and light red*

*Raw sienna
and Winsor blue*

11

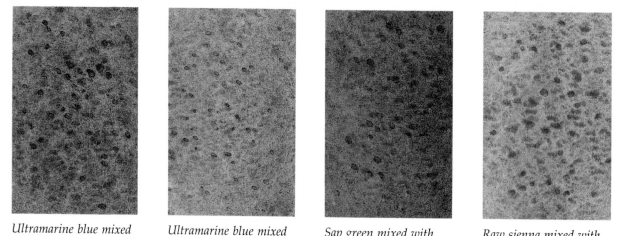

Ultramarine blue mixed with burnt umber.	*Ultramarine blue mixed with burnt sienna.*	*Sap green mixed with neutral tint.*	*Raw sienna mixed with ultramarine blue.*

These examples of granulation were all painted on Fabriano Artistico 640gsm (300lb) paper.

Pigment granulation

There are a number of pigments that dislike each other chemically and when mixed together they attempt to separate. While the mixture is still wet the particles of these pigments travel through the moisture and settle into the small craters of rough-surfaced watercolour paper, giving a variegated effect to the wash. Pigment granulation can be seen in the mixing well of your palette. Mix a fairly strong solution of ultramarine blue and then add an equal amount of burnt umber – mix together and then watch the action of the pigments separating.

Stretching paper

If you want to use lightweight paper for your paintings you should stretch it first – it is not difficult. You will need a shallow dish large enough to take the sheet of paper, a painting board and some brown-paper tape.

Soaking the paper stretches its fibres and makes the sheet slightly larger in size. As the gummed-down sheet dries out it shrinks again and becomes taut. Leave the paper attached to the board during the painting process – having been stretched it will not cockle when you apply paint to it.

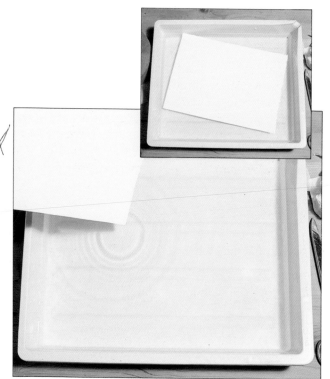

Stage one
Submerge the sheet of paper in a tray of water and leave it to soak: after about ten minutes, carefully remove the sheet and allow excess water to drip back into the tray.

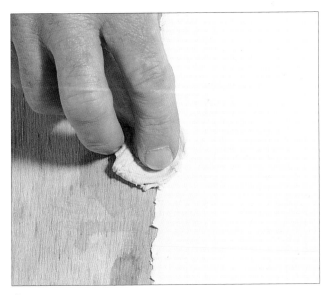

Stage two
Place the sheet on the painting board and remove excess moisture from the edge of the sheet with some dry tissues.

Stage three
Fix the paper to the painting board with four strips of gummed brown-paper tape and put to one side on a flat surface to dry.

Painting outdoors

When painting outside there are a number of items that you might consider adding to your bag. I am always dropping things, and small items seem to have the habit of disappearing into thin air when dropped into grass, so I spread a groundsheet beneath my easel. I take a screw-topped jar to hold water (again, small jars always seem to topple over), a small portable seat and an art case to carry spare paper and mounts. Of course, a pot of coffee or tea is more than welcome!

However, it is easy to overload yourself on painting or sketching trips, so try to restrict yourself to the bare essentials.

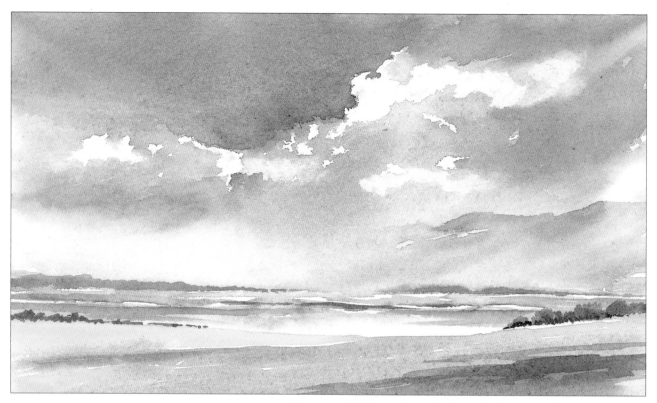

If you want to have a busy sky keep the foreground quiet and simple.

Painting skies

If you want to paint landscapes you do need to be competent at producing a number of different skies. After all, the sky area will usually take up at least half of the painting – sometimes even more. Study the composition of clouds. Clouds have shadows, usually underneath them when the source of light (the sun) is above them. When the sun is low on the horizon the shadows will sometimes be on top of them. In any event we need to make skies interesting – but do not overwork them.

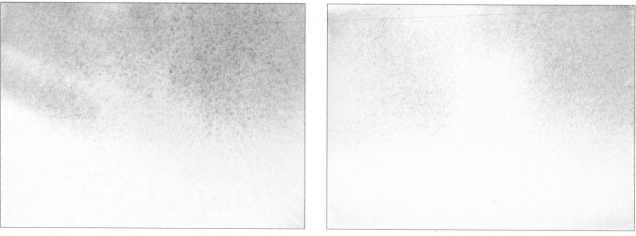

Two useful sky washes: (left) ultramarine blue brushed into a wet light red; (right) a mixture of ultramarine blue and brown madder alizarin brushed into a wet Naples yellow.

14

A colourful hazy sky made from Naples yellow, light red, ultramarine blue and brown madder alizarin. Useful when a warm atmosphere is required.

This is a cooler sky but it still indicates some sunlight behind the hazy clouds. It is made from the same colours as the above example but with a little less light red and brown madder alizarin.

This is the type of sky seen most often. Cobalt blue and a little neutral tint make the grey areas, while the blue sky comes from just a little cobalt blue laid down on dry paper.

Painting trees

It has been said that if you can paint trees then you can paint landscapes. Well, that may not be quite true, but it certainly helps.

The problem with painting trees is that we know that there are tens of thousands of leaves on a tree – and we are tempted to try and paint most of them. This is best overcome by half closing your eyes and observing the overall shapes. Keep your brush strokes simple and loose and beware of those overpowering greens; it is better to mix your own more subtle hues.

Use cold colours for winter trees and brighter, warmer colours for summer and autumn trees.

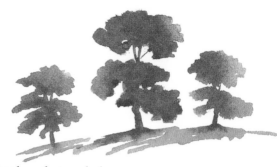

Note how the trees look lonely! It is sometimes best to link them together by overlapping them as in the example below.

Sap green and burnt sienna have been used here. Running burnt sienna into the wet sap green has encouraged the subtle blending of the two colours. I used burnt umber for the tree trunks, raw sienna for the foreground, and cobalt blue for the background trees.

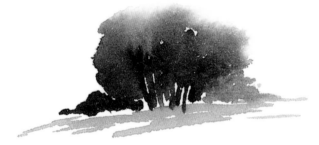

Just paint the overall shape of trees, not too much detail.

An attractive group of trees painted wet-into-wet using burnt sienna, brown madder alizarin, burnt umber, raw sienna and neutral tint.

Here I have used a wet-into-wet mixture of cobalt blue and burnt sienna to depict winter trees that have retained their foliage.

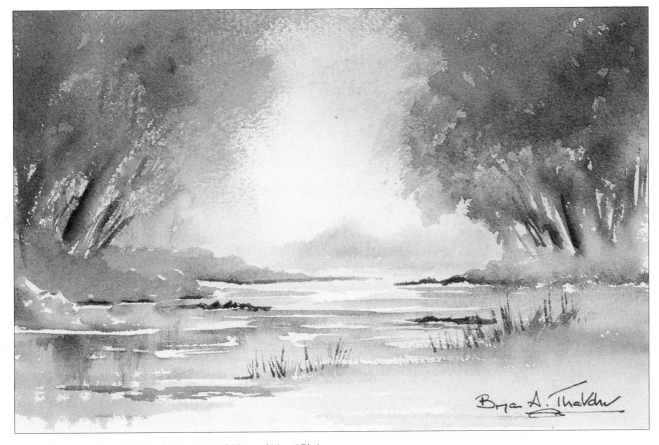

These fir trees are made from just a few simple brush strokes.

A dry brush carrying burnt sienna has been used to depict the outer foliage of this tree. Burnt umber was then run into the damp colour and a little sap green, burnt umber/neutral tint and raw sienna were added in the lower areas of the trunks and grasses.

Burnham Beeches. *Original size 280 x 380mm (11 x 15in) A picture similar to this one is demonstrated on pages 34–37.*

A rolling breaker is not the easiest of subjects and several minutes of observation would be worth while. The whites behind the main breaker were scratched out with the point of a knife.

Painting water

An area of water, be it a pond, a lake or the sea, can greatly enhance the interest in a painting but beware those muddy ponds and lakes. Use artistic licence and clean them up! Do not miss the opportunity to reflect attractive lights from the sky.

One important tip: water is usually horizontal, so use horizontal brush strokes to depict the flatness of the surface. Upright brush marks can be added to suggest reflections.

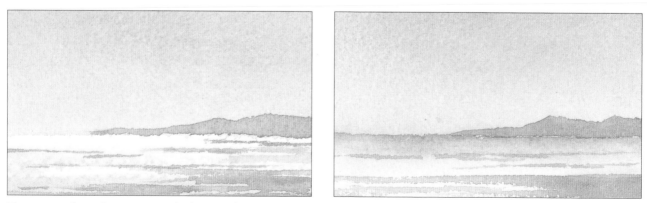

Two ways of treating water on the horizon line. Left: the tone of the water gets lighter as it recedes. Right: the tone of the water gets stronger as it recedes – this approach can often tend to cut the painting in half.

A round brush has been stroked through an area that has been previously dampened with water.

A flat brush stroked across dry paper will indicate sparkle.

A touch of warmth and a few darks in the foreground will help bring that area forward.

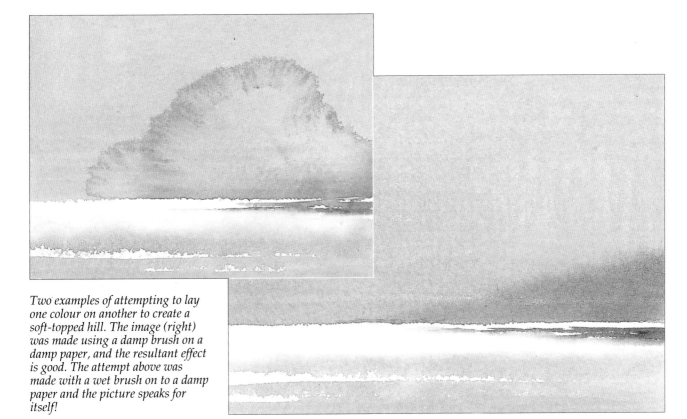

Two examples of attempting to lay one colour on another to create a soft-topped hill. The image (right) was made using a damp brush on a damp paper, and the resultant effect is good. The attempt above was made with a wet brush on to a damp paper and the picture speaks for itself!

Painting figures

Simple figures can work wonders for a street scene. There is no need to paint carefully considered portraits – just a few simple brush strokes are required. Note that my figures do not have necks, hands or feet. Lots of practice will help here.

Study people whenever you can – watch how they stand, how they walk and how they converse with one another.

There are one or two points to watch out for. Do not make heads too large. Do not be tempted to paint too much detail. Do make sure that your figures are not too large when compared with the nearest doorway!

Figures are more convincing when painted in groups rather than as individuals.

These two characters are obviously standing still and facing each other. Note how the depth of colour draws the right-hand man forward.

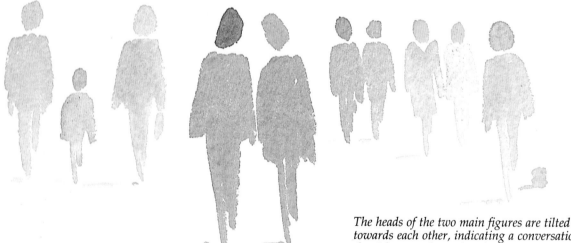

The heads of the two main figures are tilted towards each other, indicating a conversation. Note that I have made one leg shorter than the other to indicate a walking movement.

A little more colour and tone on the nearest figures will help the perspective, but do keep it simple.

The two central figures have been painted initially in light red. The other colours have then been added wet-into-wet while the light red is still wet, allowing the colours to blend.

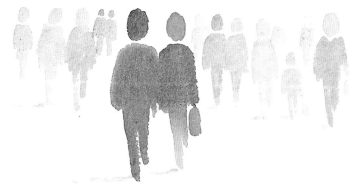

Painting figures in bright colours can depict a bright spring day.

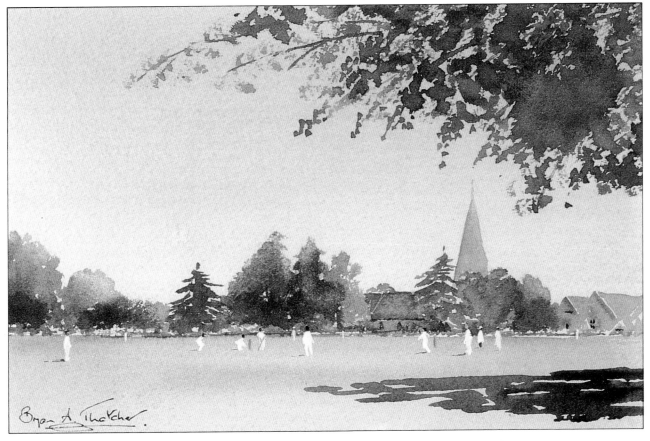

Cricket match on Chorleywood Common, Hertfordshire. *Original size 200 x 300mm (8 x 12in). All the figures were added when the rest of the painting was dry, using opaque body colour.*

21

Painting boats

Boats always make attractive compositions. Upright masts and sails contrast nicely with the horizontal water. Keep compositions simple. I find it best not to overwork any reflections – a few simple brush strokes will work very well. Add some reflections while the water area is still wet, then add a few more when it is dry. This will add variety to your painting.

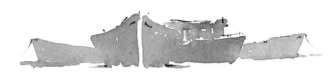

A quick colour sketch made on location can be useful for future reference. There is no need to include too much detail.

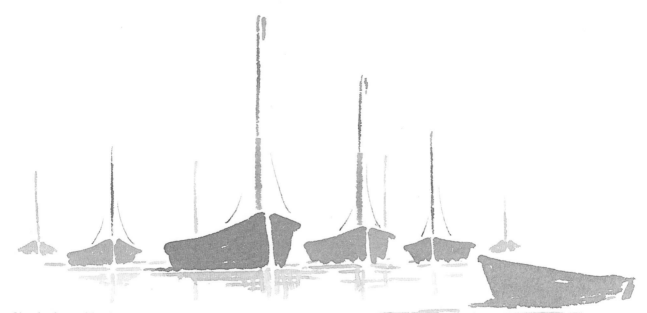

Simple shapes like these can be used to indicate a busy harbour. Note how the distant boats are cooler in colour, helping them to recede.

In this composition I have linked the boats together by adding shadows and some overlapping. Spaces between objects can be a problem and cause uninteresting areas in a painting.

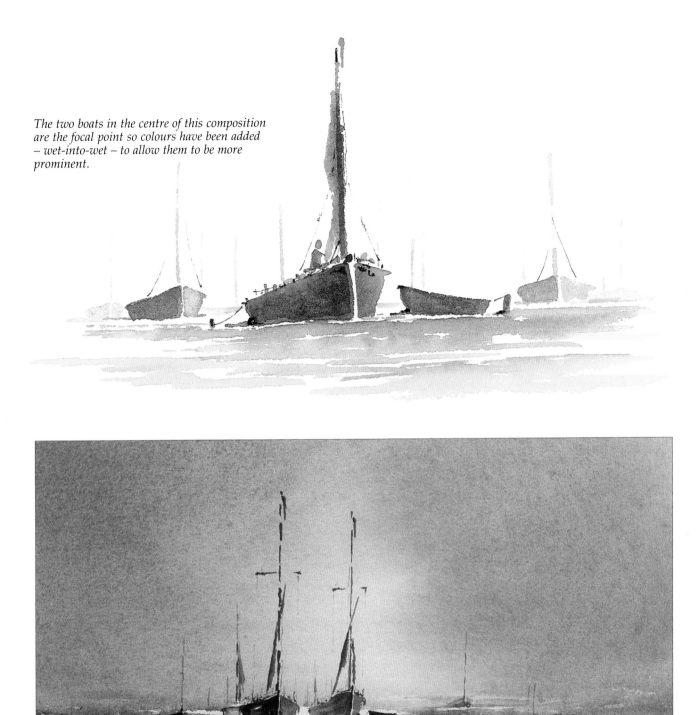

The two boats in the centre of this composition are the focal point so colours have been added – wet-into-wet – to allow them to be more prominent.

Boats at Maldon, Essex. *Original size 560 x 760mm (22 x 30in).*

Original sketch.

EQUIPMENT AND MATERIALS

Brushes
38mm (1¹/₂in) flat wash brush
25mm (1in) flat chisel-edge brush
No. 4 and No. 6 round brushes
No. 3 rigger

Paper
Rough-surfaced 400gsm (200lb), size 200 x 290mm (8 x 11¹/₂ in)

Colours

Brown madder alizarin

Cadmium red

Burnt sienna

Cobalt blue

Neutral tint

Light red

A walk in the snow

STAGE-BY-STAGE

One real advantage of painting snow scenes in watercolour is of course that we can use the white of the paper for the snow itself. The work is half completed before we begin!

Should you not wish to paint out on location in extremely cold conditions for long periods, why not produce one or two five-minute pencil sketches instead? These can be used as references back in the warmth and comfort of the studio. The camera can also be used, but do not be tempted to copy photographs too slavishly, as the limited range of tones within a photograph can be very misleading.

If you do decide to venture out, limit your materials to a minimum – but leave room for that vacuum flask of hot tea!

In this demonstration I take you through all the stages of painting the scene depicted in the sketch (left), and explain how I use different brushes and various colour mixes to achieve the end result. You will note that in the finished picture I have decided to include three figures rather than the two in the sketch.

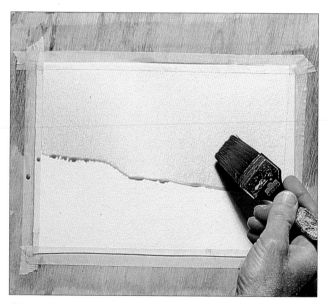

Stage one
Mix up thin washes of light red and cobalt blue. Wet the area of sky with clean water and then use the flat wash brush to add the light red.

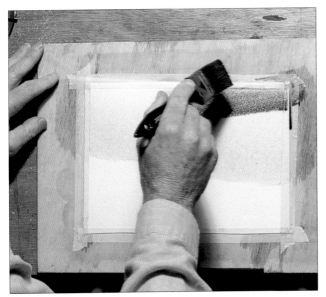

Stage two
Start to add the cobalt blue while the light red is still wet, beginning at the right-hand side of the picture.

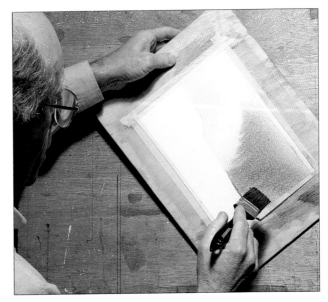

Stage three
Tilt the painting board to allow the cobalt blue to run away from the centre of the painting, leaving a light in the sky.

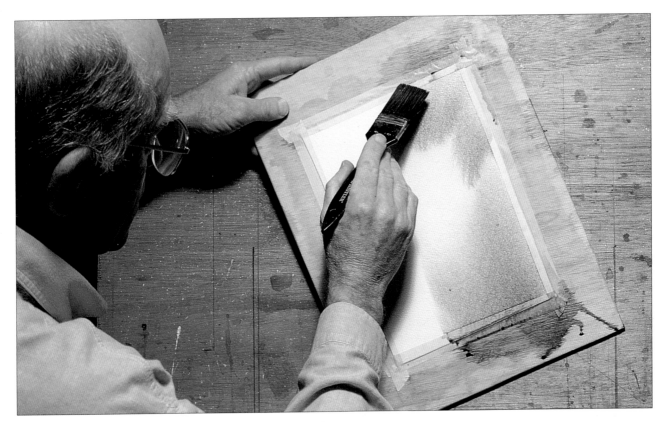

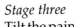

Stage four
Now add cobalt blue to the left-hand side and tilt the board again to create a light area in the centre of the sky. When you are satisfied, put the picture on a flat surface to dry.

Stage five
Mix a little brown madder alizarin with some cobalt blue: this colour is for the trees at the left-hand side of the picture.

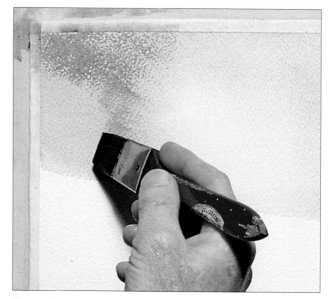

Stage six
Add a little of the mix to a flat chisel-edge brush and then paint on to the dried paper indicating foliage on the winter tree.

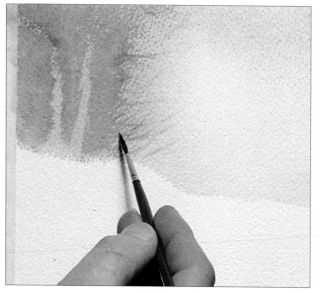

Stage seven
Change to a No. 4 sable brush and using the same mixture flick on one or two suggestions of branches. Lay colour around the indications of the tree trunks.

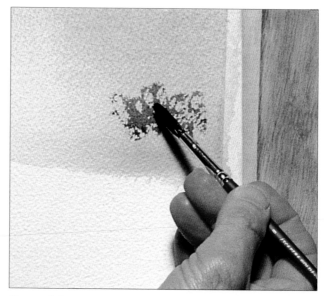

Stage eight
Use a stronger mix of the same two colours to paint in the trees on the right of the picture. The brush should not be too wet: this will allow a dry-brush effect to leave lights appearing through the trees.

Stage nine
With a clean dry finger, push some of the colour off the edge of the trees, helping to soften that area.

Stage ten
Dry the work with a hair dryer on a low heat setting.

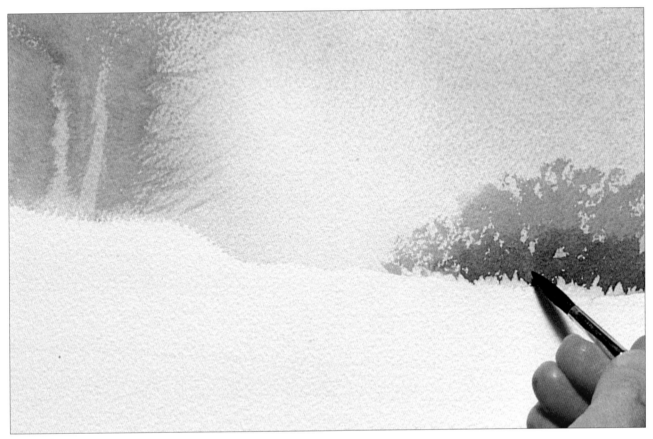

Stage eleven
Brown madder alizarin and neutral tint are mixed and a No. 6 round brush used to darken the area at the bottom of the trees on the right.

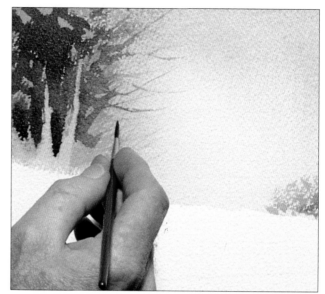

Stage twelve
Use the same mix, and the side of a round brush, to add darker foliage and depth to the trees on the left.

Stage thirteen
Now change to a No. 3 rigger brush and add a few fine branches, flicking them in with the same mixture of paint.

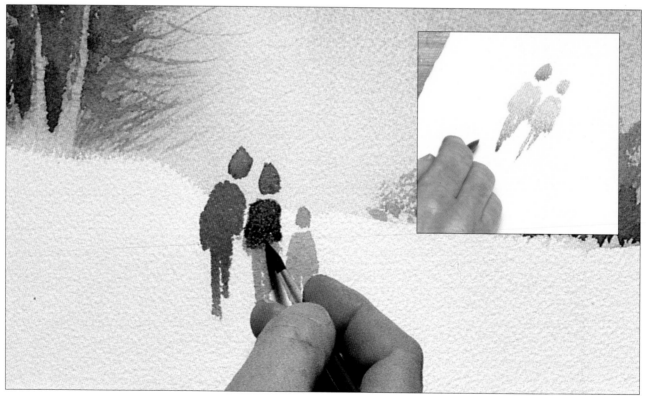

Stage fourteen
Add the figures: practise a composition on a piece of scrap paper first. Ensure that the heads of the two taller figures are above the horizon line. This helps to link up the two halves of the painting. Cadmium red is the dominant colour of the left-hand figure, cobalt blue and neutral tint of the centre figure and burnt sienna of the smaller one. All the heads are made from burnt sienna and neutral tint.

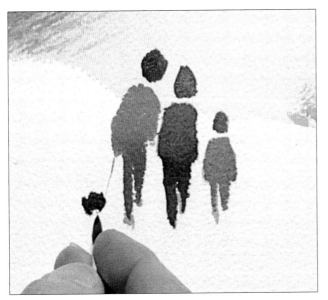

Stage fifteen
Do not overwork the figures. The dog is just a brush mark on a lead! I used neutral tint here.

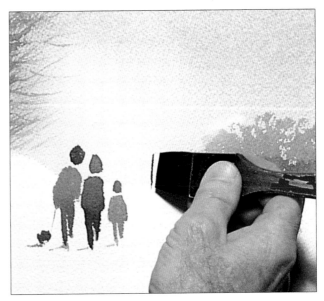

Stage sixteen
Indicate the telegraph pole using the chisel edge of the flat brush and a touch of neutral tint.

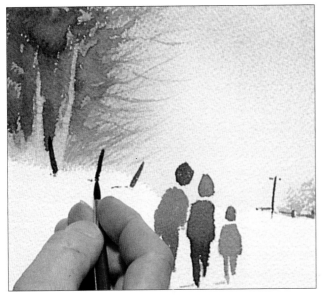

Stage seventeen
The same tint is used with a No. 3 rigger brush to suggest the fence posts on the left.

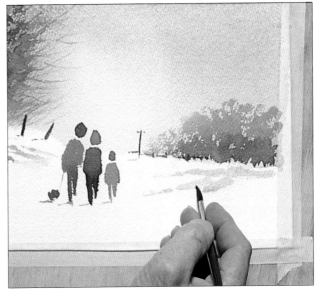

Stage eighteen
Mix cobalt blue and neutral tint and use a No. 4 round brush for the shadows in the snow at both right and left of the picture.

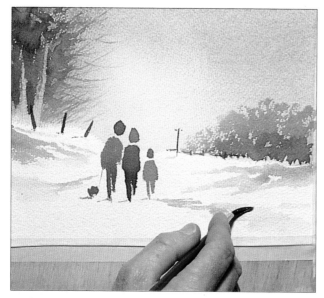

Stage nineteen
Add some burnt sienna to the foreground to indicate the shapes and shadows along the edge of the footpath and to complement the colourful figures.

Stage twenty
It is always a good idea to place a mount around the painting before it is completed. This helps to show whether further work is needed.

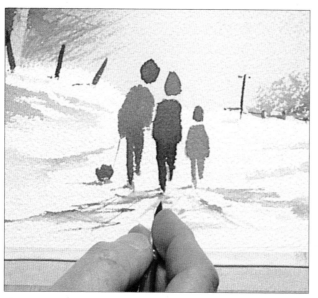

Stage twenty-one
Paint in a few footsteps under and around the figures, using a weak mixture of brown madder alizarin and neutral tint.

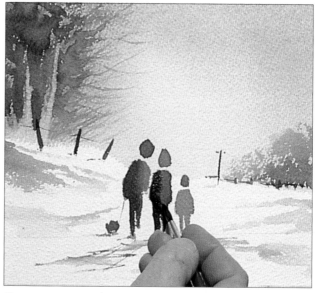

Stage twenty-two
As a final touch to the figures, add a few shadows on the left of each, using a darker tone of the original colours.

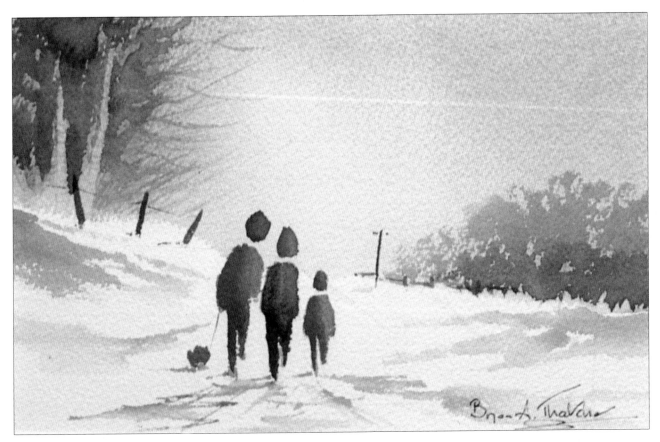

Stage twenty-three
The painting is complete – do not forget to sign it!

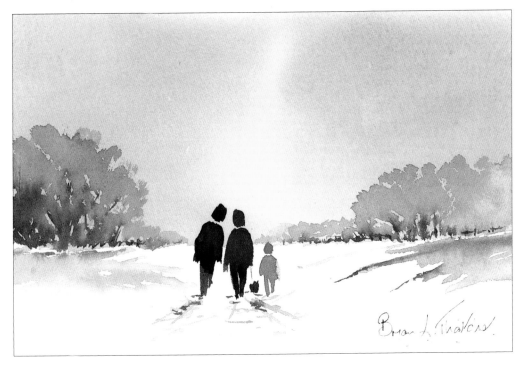

A similar subject to the one above but painted with different colours. Try this one – using your own choice of colours.

Snow in Illinois, USA. *Original size 380 x 560mm (15 x 22in).*

This attractive snow scene was inspired during a painting trip in Chicago, USA. Note how simple all the brush marks are – no real detail anywhere, everything has just been indicated.

The falling snow has been 'splattered' using a rough hogshair brush and white gouache.

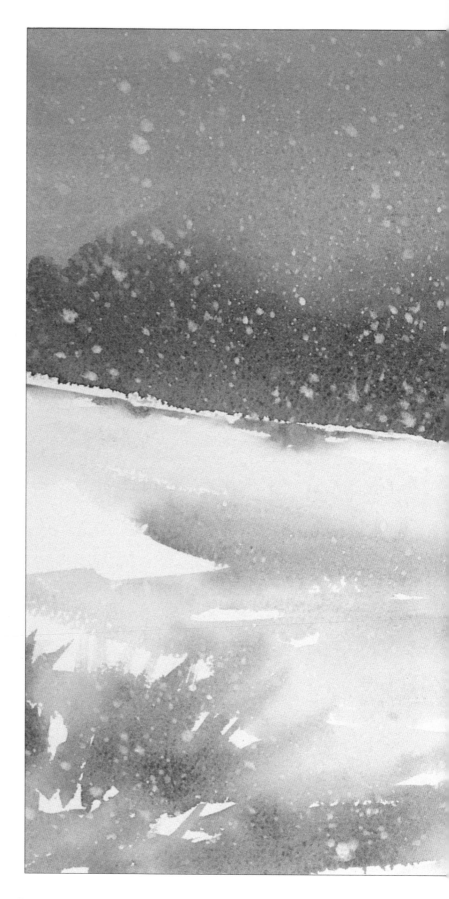

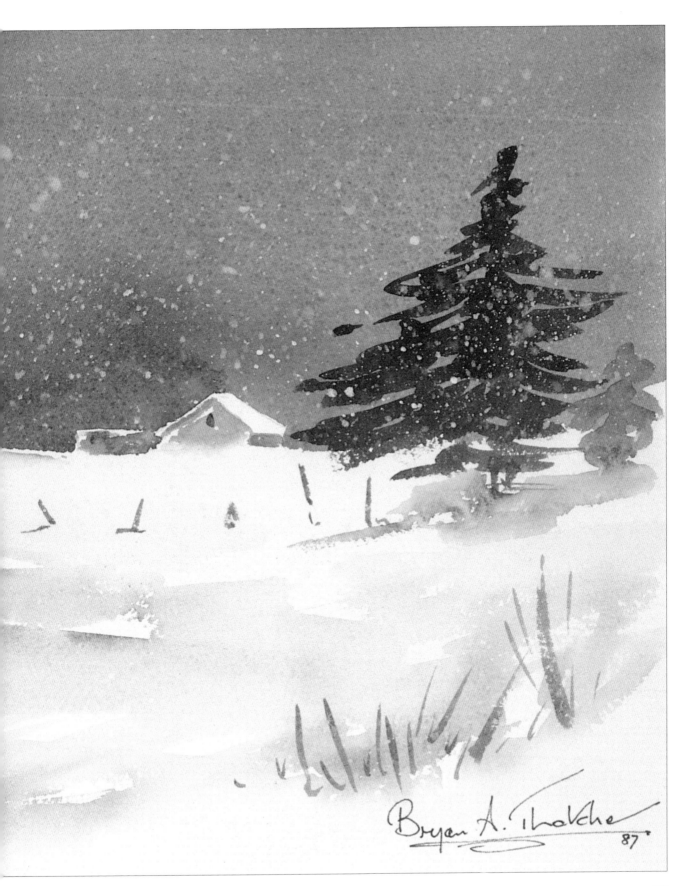

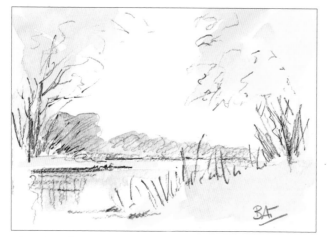

The original sketch.

EQUIPMENT AND MATERIALS

Brushes
38mm (1¹/₂in) flat wash brush
25mm (1in) flat chisel-edge brush
No. 4 and No. 6 round brushes
No. 4 rigger

Paper
Rough-surfaced 400gsm (200lb), size 200 x 290mm (8 x 11¹/₂in)

Colours

Burnt sienna

Burnt umber

Raw sienna

Neutral tint

Cobalt blue

Autumn woodland

One usually needs to venture off the beaten track to find woodland and shrubland subjects. If this worries you, you could try to be part of a small painting group.

You can find a wide range of subjects in a comparatively small area and it may be difficult to decide on a particular subject. Why not make a few pencil sketches? You could make half a dozen in the time it would take you to complete a finished watercolour. These will be invaluable when you are back in the studio.

If you take photographs, remember that when you paint from the photographs you will almost certainly have to disregard the colours and tones of the middle distance. These may be too strong in the photograph, so tone them down using blue-grey. This is known as aerial perspective and is very useful.

One last point – as always, keep the picture simple and do not overload the foreground.

Stage one
Lay a wash, made from a weak mixture of cobalt blue, over the wetted sky area using the flat wash brush.

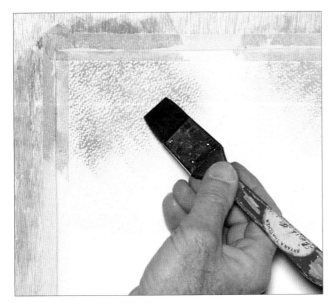

Stage two
When the sky is dry, indicate autumn foliage on each side using burnt sienna and the side and edge of the chisel-edge brush. The brush should not be too wet.

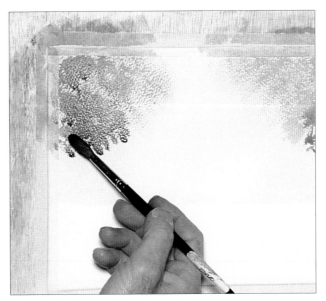

Stage three
While the burnt sienna is still wet, add some burnt umber using the side of a No. 6 round brush well loaded with paint.

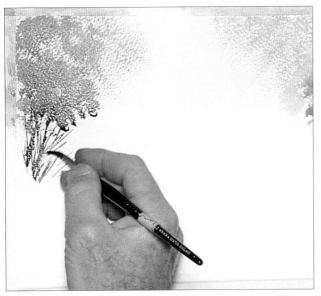

Stage four
Now paint in the tree trunks on each side with a mix of burnt umber and neutral tint and a No. 4 round brush.

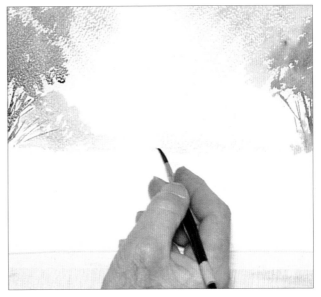

Stage five
Mix up some cobalt blue with a little neutral tint and paint the trees in the middle distance.

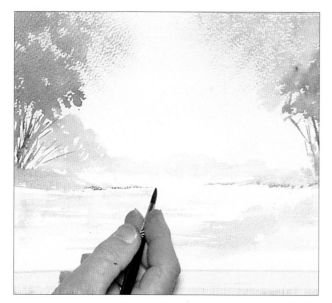

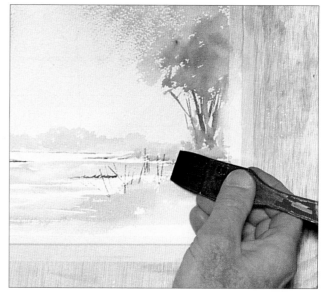

Stage six
A mix of raw and burnt sienna is used for the bushes and grass areas on either side of the picture and in the right-hand foreground.

Stage seven
The edge of the flat chisel-edge brush is useful for adding the reeds. A mix of burnt umber and neutral tint has been used here.

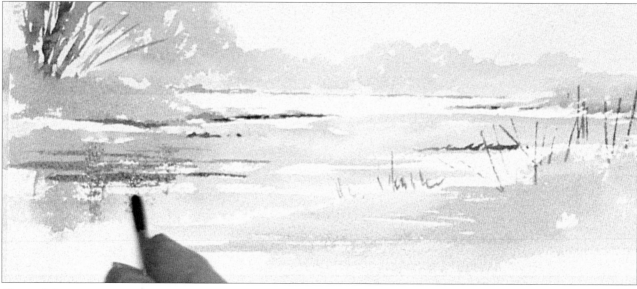

Stage eight
Lay down the water in the pond using horizontal brush strokes. Cobalt blue, a little neutral tint and burnt umber are the colours. Add an indication of reflection with a couple of vertical strokes through the water.

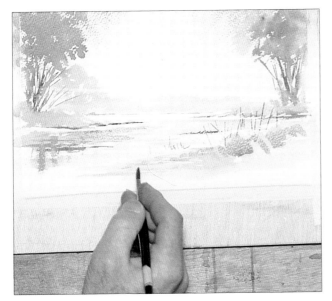

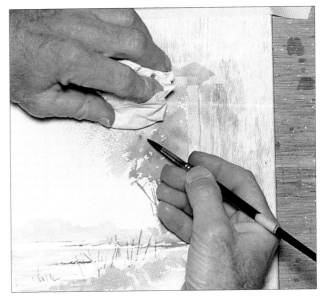

Stage nine
Add a bit more depth of colour in the foreground, paint in a few more reeds and the painting is almost complete.

Stage ten
Earlier, I unfortunately dropped a speck of bright colour into this tree. You can remove such blemishes using clean water and a paper tissue.

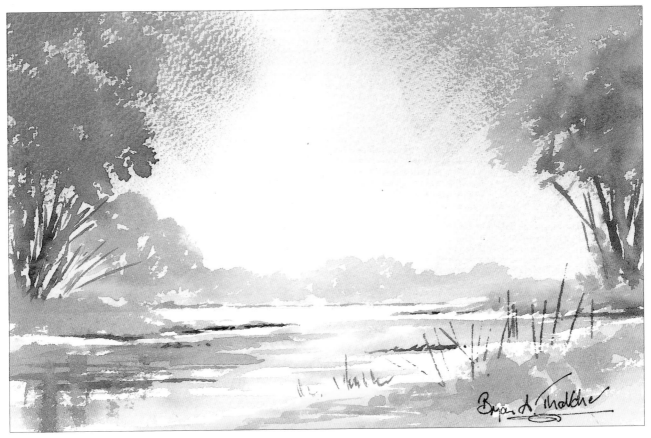

Stage eleven
Do not forget to sign your finished painting.

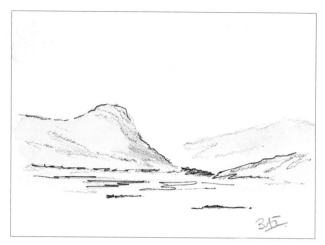

Original sketch.

EQUIPMENT AND MATERIALS

Brushes
38mm (1¹/₂in) flat wash brush
No. 6 round brush
Small sponge

Paper
Rough-surfaced 640gsm (300lb), size 200 x 290mm (8 x 11¹/₂in)

Colours

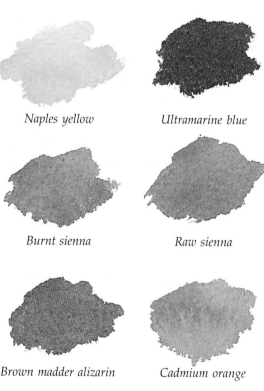

Naples yellow *Ultramarine blue*

Burnt sienna *Raw sienna*

Brown madder alizarin *Cadmium orange*

Mountain landscape

STAGE-BY-STAGE

There is no doubt that the sky plays an important part in most landscape paintings, and therefore has to be interesting. Skies have their own compositional make-up, but you can move the clouds around to suit the composition of your painting. For example, if your foreground is 'busy' on the left-hand side of the painting, consider a little more cloud formation on the right-hand side of your sky. This will help to balance the composition.

A common fault in landscape painting can be the overloading of detail in the foreground, so remember to keep it simple – no tufts of grass appearing from both bottom foreground corners!

The focal point is, of course, the main area of interest in a painting and it is usually a good compositional idea to keep this away from the central point. Just a shade to the left or right would be better.

Above all, keep the whole painting simple – and do not forget to add plenty of interest to the sky.

Stage one
First of all, lay a wash of Naples yellow over all of the sky area. While this is still wet, add a mix of brown madder alizarin and ultramarine blue to the top and both sides, leaving a light area in the centre.

Stage two
Paint in the hill on the left using a strong mix of brown madder alizarin and ultramarine blue. The greener area is made from cadmium orange and ultramarine blue.

Stage three
The lower hill on the right is indicated with a light mix of cadmium orange and ultramarine blue. I have used a clean finger to push colour away and so create a soft edge.

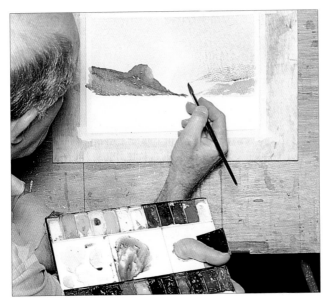

Stage four
Now put in the hill in the middle distance with a mix of ultramarine blue and a little neutral tint.

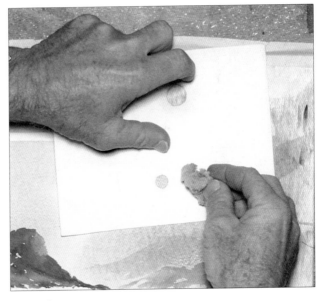

Stage five
Use a small clean sponge to wipe out a moon with the help of a paper stencil.

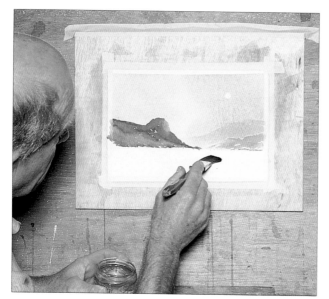

Stage six
Add a little Naples yellow in the water area to reflect the sky in the water. Then use a wash brush and clean water to wet the water area, leaving some dry paper in the centre foreground.

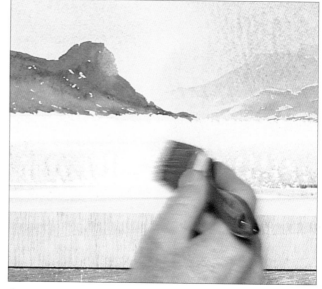

Stage seven
Use the wash brush to lay a mix of ultramarine blue and a little brown madder alizarin into the dry area of the water at centre foreground to give a bit of sparkle.

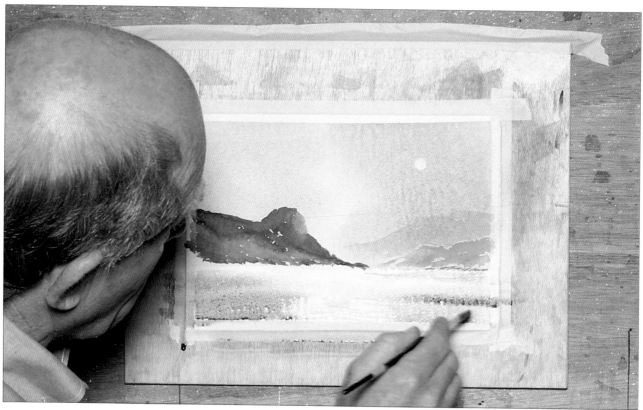

Stage eight
Add more colour to the palette and paint in a stronger tone on either side of the lake. This helps the lighter area in the centre to become more prominent.

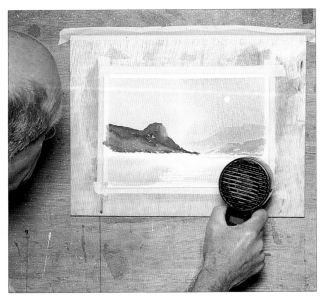

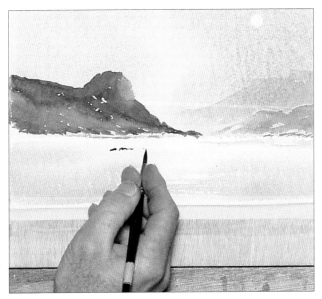

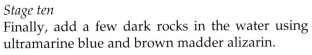

Stage nine
Dry the water with the hair dryer.

Stage ten
Finally, add a few dark rocks in the water using ultramarine blue and brown madder alizarin.

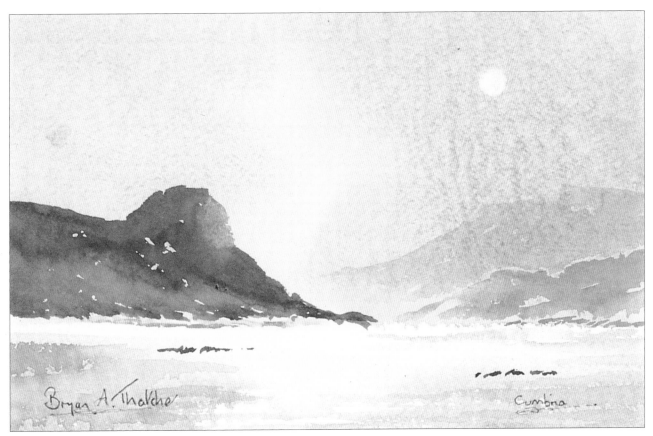

Stage eleven
Well done – now sign it!

Great Gable and Wastwater.
Original size 380 x 560mm (15 x 22in).

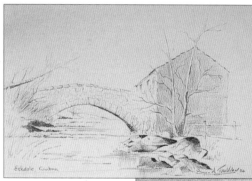

Eskdale in Cumbria.
Original size 280 x 380mm (11 x 15in).

Painted from the sketch (inset). The sketch was made with a 4B pencil on a watercolour board which I had previously tinted with a mix of light red and cobalt blue.

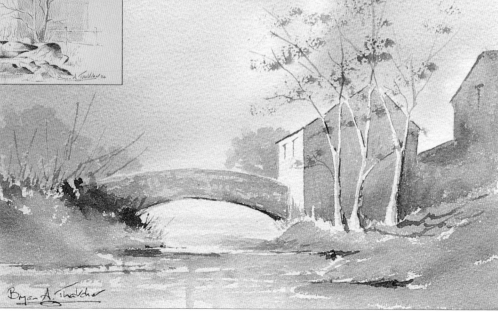

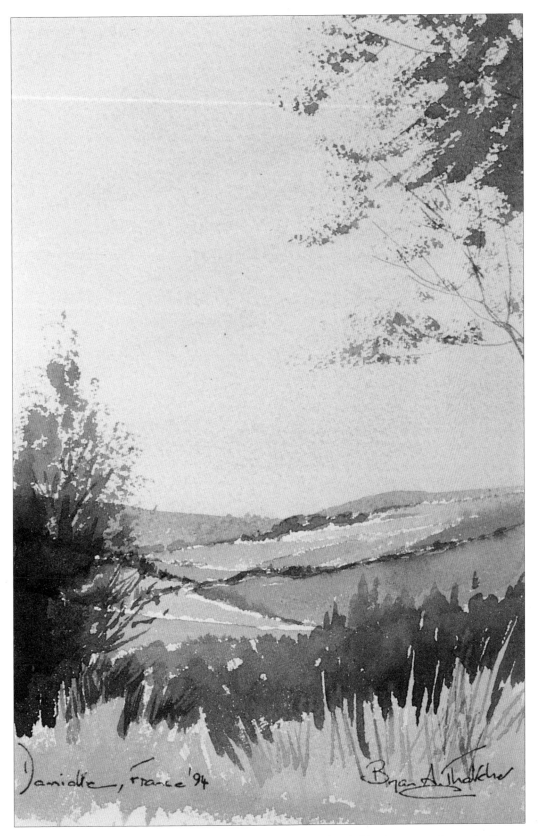

The Tarn valley, in south-west France, is the subject here. I painted this picture as a demonstration while tutoring a painting course in Damiette near Toulouse.

Original sketch.

EQUIPMENT AND MATERIALS

Brushes
38mm (1¹/₂in) flat wash brush
25mm (1in) flat chisel-edge brush
No. 6 round brush
Small sponge

Paper
Rough-surfaced 400gsm (200lb), size 200 x 290mm
(8 x 11¹/₂ in)

Colours

Light red

Raw sienna

Ultramarine blue

Neutral tint

Cobalt blue

Cadmium red

Burnt sienna

Cadmium orange

Boats on the river

STAGE-BY-STAGE

At most harbours we are usually spoilt for choice when looking for a suitable subject. You do not, of course, have to paint all the boats in any group – just select those which appeal to you.

Try several viewpoints of the same subject; it really is amazing how one area can look so different from various different angles.

Take a look at the detail in and around the boats – then leave fifty per cent of it out: this is artistic licence. Similarly, if the water round the boats is an unappealing colour – muddy, for example – just change it to suit your painting.

This demonstration is a very loose interpretation of boats on the River Thames using the London skyline as a background.

The buildings are painted in a blue-grey tone to help them recede, allowing the boats to become the obvious focal point.

Stage one
Wet the whole paper and add firstly light red and then ultramarine blue to the darker areas, using the flat wash brush.

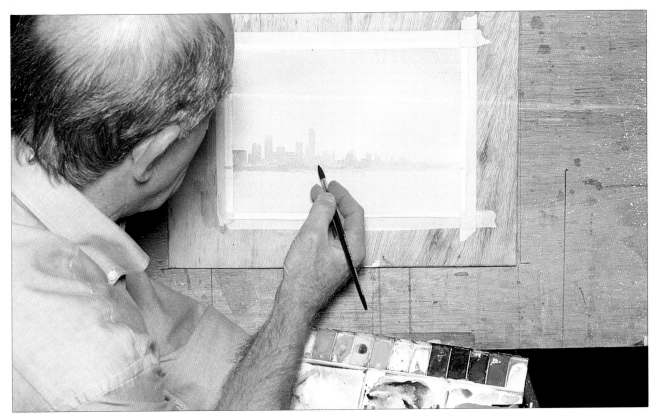

Stage two
The city skyline is made out of cobalt blue and a little light red and is painted
in after the sky has dried.

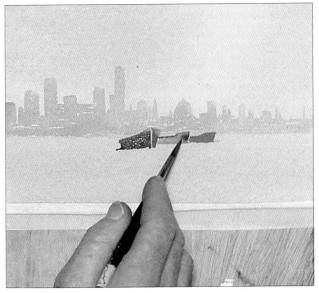

Stage three
Paint the more prominent boats using a mix of burnt
sienna, cadmium red and neutral tint. Other boats in
the group are indicated with a mix of cobalt blue and
neutral tint.

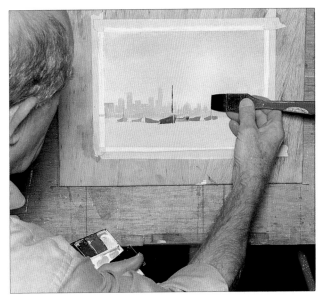

Stage four
The masts can easily be added using the edge of the
chisel brush. Use a mix of brown madder alizarin
and neutral tint for the main boat and cobalt blue
with neutral tint for the other masts.

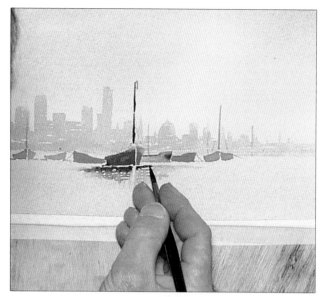

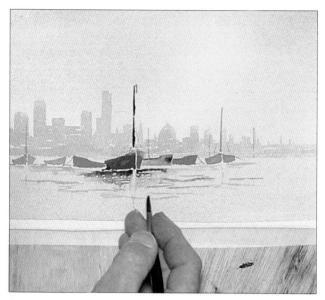

Stage five
The detail on the boats are painted with cadmium red and cadmium orange. The shadows under the boats are a mix of ultramarine blue and brown madder alizarin. Use horizontal brush strokes to emphasise the flatness of the water.

Stage six
Add a few ripples in the water with a weak mix of cobalt blue and neutral tint and the painting is almost finished.

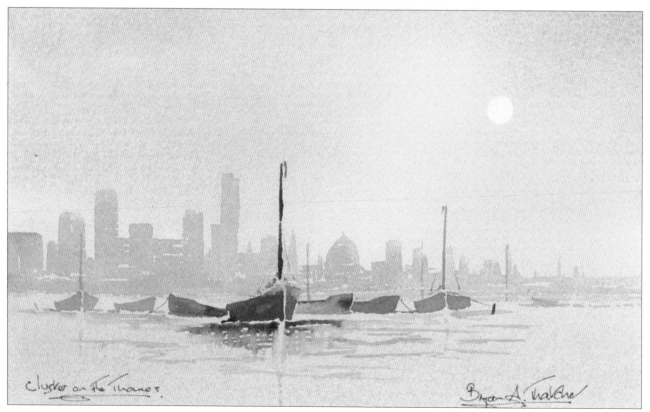

Stage seven
Finally, wipe out the moon with a sponge and the paper stencil.

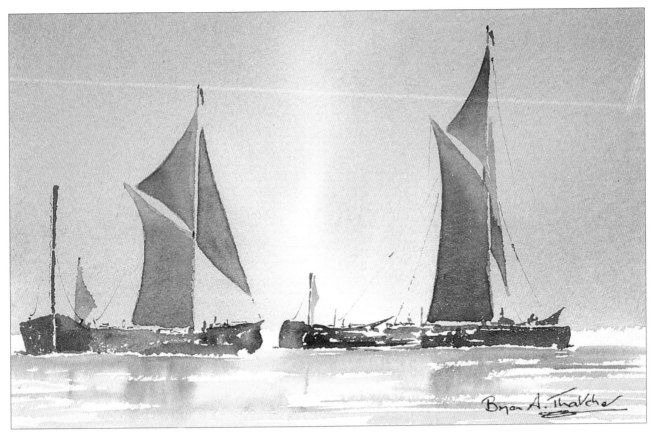

Barges on the Thames. *Original size 380 x 560mm (15 x 22in).*
Note how the sky adds drama.

The Algarve, Portugal, 1992. *Original size 280 x 380mm (11 x 15in).*

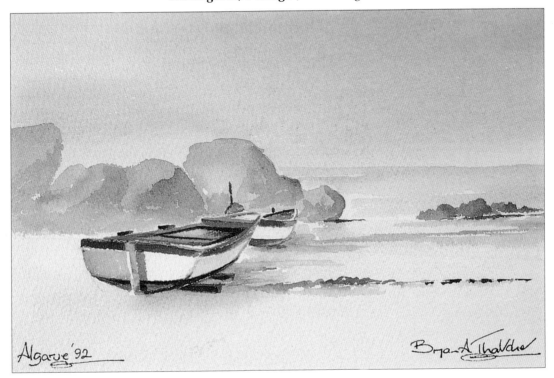

Index